# EAGLES LAND

## BESAR KURDISTANI

PARTRIDGE
A Penguin Random House Company

**To order additional copies of this book, contact**
Partridge India
000 800 10062 62
www.partridgepublishing.com/india
orders.india@partridgepublishing.com

# EAGLES
## LAND

# CONTENTS

## IMAGINATION WORLD

# CONCRETE WORLD

Yeah it is right, that words are not like a bullet, and pens are not like a pistol, but still both users are human being. In both cases, they can do good or bad things with it, it depends on each person.

I believe that, when any writer use their skills in a bad way or emphasizes rather than suggest their ideas in a quiet tone, they are deterioration our universe and filling it with hate, racism, phobia, and disloyalty.

We should respect our differentiation and similarity between us. At least we have one culture "we are human being", and subculture stuff must not give us a prerogative to create a mess in this world.

Through our writing, we should feed people with brotherhood, hospitality, and charity . . . etc. I am living under four colonizers country and that is not easy. But still i have faith that we can get our Freedom by peaceful activists. Definitely, i can say that if we hated each other, we will be empty from love, charity, faith, and life. That is why we should live like a baby, love everything in this world. And live like an old man, be aware from everything in this world.

Besar Kurdistani

"Goodness towards (one's) parents is the greatest obligatory act."
Muhammad PBUH

Of everything else the newest; of
friends, the oldest.

Kurdish proverb

# IMAGINATION
# WORLD

# Debating between
# Mr. Facebook and Miss. Slander

Now I am following my fate. It does not matter what will happen to me. I am in my own boat, I have my own plans. Simply put I am optimistic—I can discover illumination in darkness. I have faith that no one can defeat me. I will forgive, but forgetting, no way. I suppose that when you sprinkle salt on the ice, you cannot keep it from dissolves.

Life taught me that if we don't preserve our faith in trust, love, and care too much, we will be brilliance forever. Already I have made my point—people around us like a piece of chalk. If we used too much for "trust, love, and care", they will make us sloppy as much as our overstatement. but if we take off that too much, we can handle whatever they are doing to us and, can pure ourselves by rethinking and recreating, not by inebriety and useless drama.

I have no intention of disturbing you much. I just want to tell you a brief quotation from my mate's inspiration "A man can be destroyed but not defeated".

Oh love, you force me to bring out my personal secrets. I know you want to be free like others. She insulted you as much she did it to me. Don't worry! I will let the Universe know about that tragedy, that scandal, that slanderous girl.

In college, I was a very shy and quiet Student, not communicate and participate in any events. They called me Mr. Facebook because even during lectures, i would use it. Everybody was familiar with my habit including my professors. This infatuation got me to the point where I did not want to have any link or communication with anybody. From their side, they ignored me, because they felt that, i had some mental health issues and this made them anxious to avoid me. But they had misunderstood me: I just wanted to nestle in my own cozy world inside this wild world. In college, i knew only two places library and my classroom. I did not care about fashion and other extras, for it was a challenging task to read, write, and listen to lessons. More than half of my salary went in buying books, and audio material. Till that time i had a clear philosophy: study, study and study.

During autumn, in my sophomore, for the first time in my life when, i entered my department, my gaze rested on a girl whose beauty struck me as phenomenal. I could not help but stare at her longingly. This came as a surprise to me too myself, since it was not my demeanor, to do such things, as i was renowned for my timidity. I gazed at her till my body shook with the sheer ecstasy of her beauty.

Her voice was like piano during opera chorus, played near a shore. It was like a singing of sparrow, during spring near a spring. When i raised my head and plunged into her eyes, their depth was unimaginable. Her eyes were sparkling like the moon on a clear summer night in Kirkuk. Her face was like a daisy. Her lips were like tulips. Simply i can say that, she was like a Venus, entering my poetry from everywhere.

After a while, she walked away from my eyes but her voice and her magic still murmuring in my head. At that time, one of my classmates came and said to me "Hey Mr. Facebook if you want to be friends with that girl, i am ready to help you". I was so nervous, and with a fake smile told him how? He start laughing and told me, hey everyone knows that i am Mr. Jerk in college. He gave me her Facebook account, before saying to me bye, he told me "Mr. Facebook if you used your talent with a little courage, you can do it, be like a spider and have a meek.

I did what he told me, i don't know whether it was courage or something else, but I sent a request across which she accepted. We started chatting with each other, texting, commenting and liking each other's posts regularly. One day Facebook said it was her birthday tomorrow. This was a godsend opportunity since for a long time, I had been planning to meet her face to face, and what better time than this? So i inboxed her and told her that, i want to celebrate her birthday together in our cafeteria. I did that with some decoration. It was a short poem with a marvelous video. I did not log out my account, till she replayed me. Yeah Mr. Facebook, it will be wonderful to gather in a real life for the first time for my birthday.

The whole night, i was anxious because I had never been to the cafeteria before and second I would have to speak face to face with her. If you want reality, even cogitation about speaking with her made my body in a strained situation.

For that day, i woke up early and went shopping directly. First i bought a large teddy as a gift for her birthday. After that i bought a special Red Velvet Cheesecake. I called Mr. Jerk to lend me a hand in decorating the cafeteria for me. Thankfully he was free at that time, and he did that for me.

We changed the very mood of the place with colorful strings, tabletop candles, and balloons. When she entered the Cafeteria, music was started as we played and hummed along her favorite song. She was most impressed and so for the first time in my life a close friend of mine was a female.

When i sent a request for her account, absolutely she knew for what purpose i did that. At each step I did, for being near her. She magnetized me and reacted the way i like. It was clear for me that she likes the way i am treating her.

One day, she called me aside after the class. She seemed pretty nervous as we took a stroll in the campus garden. After a brief spell of silence she blurted out: "hey you know, i broke up with my boyfriend. It is true that, i loved him so much but now it is impossible to enter into a relationship again. Only Allah knows what will happen to me." I felt so lucky that she is not in a relationship anymore. From now on, it is my job to heal her wounds, to make her feel strong. I must show her that she deserves all the best in this life. I ought to be successful in bringing her smile came back to life.

We became so close, to that point we could be called boyfriend and girlfriend. I used to send her love poems which i wrote for her sake and she would receive it warmly, and respond with great enthusiasm. On each occasion, she would respond that i am a miracle boyfriend, and she is very happy with me.

Once, in the afternoon, as I went to a tea shop in bazaar and tried to think deeply about my project, because first it was a Sunnah to marry and second she was my very soul. So i called that project "winning heaven".

After drinking half of my tea in a large glass that was more like a tea kettle, I heard a sound in my mind "hey, what are you doing crazy man?" I am doing well because I am sure that she loves me. By the way, do not forget that she calls me, my boyfriend. You know better than me that such things are taboo between friends.

Believe me, I am not that stupid, to do such trivial acts. Some days ago, she sent me emoticon kiss, heart, and ring with a head line "To my loyal soul." In the whole world those things are not normal between just friends. Maybe you feel that it is not enough. But it is not only my idea as our friends also feel that. Things are not proceeding naturally between us.

The day after that was Friday, so it is Mosque day. Before going for the prayer, i gave her a call. Hello my lovely girlfriend, what's up? She said that she is feeling good now because she heard my voice. All of a sudden I told her that, i am so bored and cannot handle anymore. I want to finish our process and marry you. She asked which process? She began laughing, laughing, and laughing. She told me that, she has such a perfect boyfriend and has a plan for everything.

Stop laughing, don't insult me anymore. I am serious; I admire you, and want to marry you. I think we understand each other. Hey Mr. Facebook, it is not about you but i do not want to get married. I was shocked by her answer, and after pleading with her, she promised me that she will think about my proposal.

The sound came back to my mind again, hey maybe she is a good player. She is playing with your feeling. I know you are her friend and did so many things for her sake. Do not forget that she told you "her heart broken, and looks to males as an enemy". She has a philosophy; everything is acceptable in war and love. So she don't care about whom you are, just want to see deleterious around her. I know you don't believe me Mr. Facebook. Be away from her and keep yourself safe. Suddenly my father called me; I came back to real life and went for my prayer.

During that month, i felt depression, and anxiety. My mind was woozy. I could not even go to college regularly. My sleeping, eating, resting, and studying were not fixable. Through my melancholy, i was lamenting. I saw grave as a mercy from God.

When the time came, i sent a message to her mobile:

In the name of Allah, the Beneficent, the merciful

Please let this message be a secret between us, and don't replay my message till you discuss my proposal with your heart and mental together.

Hi, it is me, may be when you read my message, you feel somehow i am crazy, but yeah if you want reality, i am crazy about you.

First time when i saw you in our department, i told myself this girl will be your queen. I felt something different about you, i never felt such emotion before in my life. From that time, when i look to any girl, i remember you. When i close my eyes, all these distance between us means nothing because at that time, i feel that you are inside my body, inside my soul.

From that moment till now, you became a part of my life. But unfortunately all these dreams make me tired. That is why i told you to, please think again. I am trying all kinds of impossibilities to change this adorable dream to reality. Pleading you to help me with that, i don't mind if you didn't love me today. For me it is enough to have faith in my love. I can promise you to try my best to not let you feel regret about been a part of me. Try to make a small heaven by Allah's wish between us. But all these need your help. Believe me i cannot forget you because already you are a part of my life. It is not enough for me. I am so tired for being away from you. I need you to be my friend, partner, and my soul.

With you i can go through fires, please before taking me to the graveyard think again about my proposal. i am not forcing you to say yeah. I solely want to tell you that i am that man which loves you truly, dying for you, adoring you. Only Allah knows how much loving you, i cannot calculate it for you. So please think about my proposal again. I will be thankful if you gave me a chance for being your partner.

She answered me:

Hey lovely man, i told you before that i don't want to get marriage because i don't have such a desire right now. Be sure, if i decided, i will never find such a good man like you. You are my number one.

For that time, it was not bad news when i read her respond. I replied her.

Hey lovely girl . . .

I promise you that i will never speak about my emotion. As you said, i am number one. You gave me a chance to breathe again, so i am waiting you till the end of my life.

A few days later, I was sitting in the Cafeteria, when i heard her mates talking about her nasty business. One of them said, you know she is flattering Mr. Facebook. Already he is in her list. Other one said, yeah, i know, she tries to be a friend with boys, especially those which they are in other departments. When they fallen in her love, she broke them down. I felt a metro smashed my head, it was so painful. Just because i loved her so much, I ignored their conversations at that time. I don't know why, i felt that they are feeling jealous because she is astonishment and admiration lady.

After one year left, she sent me a message, and complained about our friends. She told me that, they are teasing, and insulting me, because still i am your friend. They told me stop playing with his feeling. If you don't love him, just be away from him and let him continuous his life with another one. Don't be so wicked girl. I interrupted her chatting, don't be

sad. We are friend till the end of our lives, don't care about people around us. Patiently, I am waiting your permission for allowing me to proposal your hand again. We will die singles or we will be together forever.

Not in the least, it is impossible such respond. Simply she printed to me:

Forget the last part, don't die single and don't wait for me. Go marry and have kids. Live your life. Don't trust my words and promises because I may change not now, at some point in my life. God knows what will happen, so i am telling you again; don't wait for me because you're not my number one.

When i saw her message, I entered a new world. I remembered her mate's speech. I don't know what happened but i took it easy. May be because she fulled me with her hate or may be i woke up from long dream. i did three things, removed her messages, deleted her mobile number, and blocked her Facebook account. After that i continued my life . . . .

Eventually, i can say that i am living my life in a pretty ways. I have a genius, and pretty wife with twin children. I am working in a big nationalist organization, and a part time work in media as an editor for critical magazine. Don't ask me about Miss. Slander, really i don't know anything about her. After what she did to me, i disregarded her like putting a handkerchief in a crush bag.

# (Racism disease)

So vapid
Should tell you
Have some days left
Sickness rife my body
It is my destiny
To die from starving
Neither me nor you
Even cannot judge life
Hate ancients
Created all these
Made a distinction between us.
Have a severe deficiency in
Love, hug, kiss . . .
Dying, starving for it
Go away, keep smiling
Before watching my grave
Do not want
Lose your family
Because of me.

# (Hero)

Don't care
It's magic
Its dream
Just horrible
Saw rain wound nature
Pasture eat rabbet
Piano destroy musician

I feel your sorrow
Don't worry
Smile
Ignore yesterday
Tomorrow
Look at the sky
There's rain bow

Don't be dramatic
Forget melancholy
Don't lament
The universe
Waits for the hero
Not the sleeping man in the cave.

# (To my fake father)

It is your function
Master in it
Had professionalism
Upon your tree
Have power
Tear out his leaves
Burn it
Do it or not
Me, different from them
Spoil me, or I do.

# (Fashion Marriage)

Told her, i can do . . .
Build a hut in a wilderness
To live in a lovely land.

Told me, is there music?
Want to be in a dance stage
To live in a dramatic land.

Told her, it is there!
Music inspirit from my heart
Producer will be my mind.

Told me, so funny
want a man from childhood
knowing nothing, merely a pastime.

# (pubic message)

Will pass away
Not now
When realize who I am
What I want
What I do

Don't care
Can play with fire
Burn me
Nothing will be change
Poet never dies

Now I am intelligent
Not the same one
Homeless cure
Pure me in that way
My name is Uncle Sam

# (Just you)

Stop it, shake me again
Take me through rivers
No life, no city, no house
Took me in present
Let me die in your jungle
No family, no grave, no treats
Me, your smiles
No need for pleads
Just your hell.

# (Emancipate)

Don't touch me
Want to listen to this music
It sings for me
Freedom, freedom

Rain, Rain, Rain
It flew me away
To the sky
Near mother
Eating apples with my angel

Rain stopped
Music interrupted
You touched me again
That is what I called life
Freedom
Only exists in dreams

# (Sincerity!)

So tired
Can you show me
How can meet him
Or buy it
Even ready
Borrow it

Mam told me
If I met him once
It means
My job is done

# (Kurdistan, Me, India)

It is the same
Black eyes shining
Twilight plays with the moon
Lips shows tulip
Slender thuja
Rains the sweetbox's perfume
Bear plays with my heart
Grant me a sense
That I am living in my land.

It is the same
Love hugs nature
Peace waiting in doorstep
In every city, village,
House, home, market,
Mountain, hill, valley,
Temple, mosque, church,
History, present
Drowned golden words
To cure my wounds
That is why I feel
I am living in my land.

It is the same
Do not call me homeless
I have felt that before
My mother
Never, ever
Belonged to my father
I was always orphan
No father, no mother
Just a child
Crying for food and fun
That is why I feel
I am living in my land.

# (Liberty)

Waking in the midnight
for searching
hopelessness going back to bed
tears again, and again
sleeping like a cat in the street
no house, no home

# (Dragon, a myth)

Fun, smile, joke, even silly poems
No matter, gives us relax tablet
Me, I will forgive not forget
Drinking girls virgin
Ripping, wedding parties
Oh man do not be cry
It is not you, look at yourself
As a gift rending your body
They loved you
That is why in a glass, drunk all daisy petals
Be faithful, every dog thanks you
They lived in poverty
Your skin, bones, even your blood
Takes them out of it
Hey man look
They destroyed all cities, villages, mosques, churches
I think they rebuild our country
They forced us to go to the mountain
To live in a natural life
To be away from dirty air
Yeah dirty air
That is why they brought to us
Apples test, oranges test, us you like
By butterflies sent to us
What a fantastic world
Lets you die in a fresh air
See all friends around you
Clapping for your Romantic view

If you hate them
You will be empty from
Faith, Life, Love, charity
Live like a baby
Love everything in this world
Live like an old man
Be aware from everything

# (Mother's magic)

O, raining again
With unbelievable music
Putting fingers in my soul
Without knocking
Please stop it, please
Don't feel, just interrupt
Don't dream, don't seek
Just wait, wind comes
Not alone, with butterfly
Brings daisy to your night

# (God misleads!)

Slamming it
do what you want
like a gang
hushed me up
deception everyone
make me malice,
odious, infamy.
like a water
can pure again and again
when he comes,
me, just cry
you, dance, smile, harmony
merely he never misleads
i win spring,
you hit . . . .

# (Kirkuk)

It's mine,
go away from paradise
it is a peaceful place
be away

Tell me way!
How can you do!
Faustus not reborn
to call Lucifer
hanging him in 2006.

# (Let's fight)

like a loan!
face to face

born to die
for freedom nothing else

Sh . . . . of you
bit whatever you want
at back side

grabbing three flowers
you forget
nature cannot be destroyed.

(Memorial poem for Sakine Cansiz, Fidan, and Leyla)

# (Told me)

Challenge life
Do what you want
Kill your panic
Deserve that

Told me
Be strong
Take a license
Be a good wrestling
Simulate everyone
Deserve that

I did
Exist as I am
Just a wheelchair
Selfishly, invert you
Made you
Canceling your symbol

# (Public hanging)

Nice usher,
Sentences come from you,
Accuse me,
Call me whatever you want,
Power may destroy tree,
Not roots.

Not my fault
From Adam i came
By God's will
Not me, not you
From blood, i am Kurdish

Bring friends, family, and folks
These celebrations never finish.
Target us, no regrets
So proud
Going from dust to dust
Confront death for freedom

# (hold on)

Nothing can do
Like a gypsy
Read hands
Destroy futures
Hung me out, salvage me
Reverse tomorrow
Give a tip
From your lips
Make me immortal man
Nobler than others
Transferring me
Form nothing to everything.

# (For you)

Open your heart
Don't speak with your lips
You are angel
Don't act like human!
Don't seek for freedom
Just look to the ground
Am kneeling to your soul.

# (Destiny)

Moving a chair
With a tic tac
Murmuring and smiling
How a wonderful
To be harmony with nature
This is Eid
Ornate to be heed.

Rings on the Skype
Now understand
Life is miserable
Can biting anytime.

# (Father! Father?)

Asked father
Dad, what is life?
Is it struggle?
With a fake smile
Son, it is simple
Like working in an Elevator
In a day
Some costumers are cool
Others like nothing
Dad so!
Try to not be fire
I got, like a chess
Sacrifice everything
For only one.

# (Consideration)

Let you travel
All universe
Not for pleasure
I want
To see all disguise folks
After that you know
What human can do!

Let you study history
Not for education
I want
To recognize
Human can be wild
More than scorpions!

Disguiser and wilder man
Have more
Powerful, energy
Among you
You call them
GOVERNORS!

# (My identity)

It's so small
even lizard cannot live there
where is glory?
to put the whole world
in this tiny nasty

someone told me
ballroom is bigger than this
another one told me
doomsday can judge
don't be goof
solely go on

have my word
curiosity, illiteracy, and responsibility
for who i am
gave me superiority
for seeking of knowledge from
the dust to the dust.

# In My Way . . .

Yeah my flight starts to take off. I have strange feeling.
What i am doing it now? Why i am going to USA?
All these disturbing questions came to my mind. I am
miserable. Every time when i am taking a flight, i will
become nervous. Maybe because i don't have knowledge
what's there outside or maybe i don't want to be away
from my country, family, and friends . . .

I am flying like a bird. Try to reach Vienna, then
USA. The plane shakes me such as mother shakes her
baby. It seems that, knows that, i want to cry, but now i
am over that feeling.

There is a sweet lady behind me, in every moment
she tries to know what i am doing, and why i am acting
in a bizarre way. It looks like she is open minded and
urban Lady. She wears suit jacket, long skirt, and dress
shirt with a veil. Her personality made me safe because
i want someone be with me, and shows her feminist
sensitive like my mother. I am sure that, she is looking

in my paper, and saw whatever i am writing about her. She became smiling, but me, i am dying from my shy feeling.

Hold on! I did not leave anything. I should apologize for my behavior. If i was me, i could not be a silence when i see someone makes me a character for their writings.

Indeed, i need a small gap to escape from my own world. It is so strong, i cannot handle it anymore. With her magical smile, and attraction voice stopped me. Hey don't act like a stupid; writers must not be in that way. I know you are so envious in writing. You pay anything in your life just for writing a sentence, or even for a phrase. My face was still pale and sad, but at least her nice words made me smile.

Mam do not get me wrong, like others i have hidden side. I need injection from what is life doing it to me. My pen and a piece of paper, they are like drug for me. They are the best injection that can survive me from this grimy life. Such as black oil in mother land, outsiders can use it, but it cannot warm my folks. I know only me, and words. They don't need my inspirations. When they took my sister, mother, and my girlfriend to sell it to night houses, i could not do anything. Still I am hearing their voices, please help us. When they hanged my father naked, i could nothing. I am useless mam. They left me to cry and write words but who care? My words cannot therapy all these! This is a big question that no one dares to answer it. Still i am dying from my nightmares. I believe that one day can see me as a free man, but after what?

I Know you are from eagles land, but still so young to take off all these wounds. Look to the bright way in

life, you did not lose your wings yet. It means you can struggle, and be happy. You should be calm because your country need intellectuals not block minds. Open your window, look outside, see all these clouds, they are so amazing. Now, they are here, made this sky beautiful. May be after five minute, there will be strife between them, they will leave sky and make love with earth, we call this process raining. Whenever, these clouds forgive sky, they will go back to their places. Be like clouds, have harmony with time and place.

Whatever you said to me, you are right but i cannot handle all these. I am not an ant. Madam i have only one heart, and soul. Believe me, i don't deserve all these. In the whole of my life, i did not hurt anyone, even a mosquito. From Neanderthal till now, my folks did not asked more than what we deserved. May be because we are so peaceful, that's why we taste all these.

Look brother, as a writer, we should live in the most darkness lives to have the courage for talking about real tragedy, and also should know without darkness we cannot feel the brightness side of the moon. Use your talent in your writing, believe me, you can feed eagles mind and prepare them for last revolution.

In my childhood, i was watching Tom and Jerry. From that time till now, they are fighting and no one died. Recollected that day in kindergarten, told my teacher, one day i will see one of them dying in front of my eyes. But she gave me a memorial quotation, this is impossible my lovely friend, because they are created from words, they are inspiration us. Trying to teach us lessons in our lives, teachers never die, and lessons never end. This thing only happens in real life. Don't worry, life is so simple, what is complex is human being. So be

simple, solely get benefit from past and move on to the shining feature.

It is so odd, look to your life, before some hours, you were in Asia, but now you are flying over Europe's sky, and if you still alive for tomorrow may be or not you will be in America, everything is conceivable. We know our past and present but feature like a snake's poison, up to us, we can use it for medicine or using it in a wrong way to take us to the graveyard.

My flight landed . . . waiting for feature . . . .

# CONCRETE
# WORLD

The pictures of Doves supplied by Photographer, Sug-Tae KIM.

# The Unknown Soldier

If someday a delegate comes to my land
And asks me:
"Where is the grave of the Unknown Soldier here?"
I will tell him:
"Sir,
On the bank of any stream,
On the bench of any mosque,
In the shade of any home,
On the threshold of any church,
At the mouth of any cave,
In the mountains on any rock,
In the gardens on any tree,
In my country,
On any span of land,
Under any cloud in the sky,
Do not worry,
Make a slight bow,
And place your wreath of flowers."

(Translated from Kurdish into English
by Rikki Ducornet and Abdulla Pashew)

# Treaty of Lausanne

The Kurds are one of the oldest habitations of the Middle East. They have the rich legacy language. In 1923, they divided Kurdistan between five countries, Turkey, Iran, Iraq, Syria, and former Soviet Union. Because of Lausanne treatment they are colonized under four states Turkey, Iran, Iraq, and Syria. This treatment singed by Turkey and the Allied British Empire, French Republic, Kingdom of Italy, Empire of Japan, Kingdom of Greece, Kingdom of Romania, and Serb-Croat-Slovene State.

# Mullah Mustafa Barzani

He is a Kurdish nationalist leader, and calling him Kurdish Spiritual Father. He was born on March 14, 1903 and died on March 1, 1979. He was appointed as the Minister of Defense and commander of the Kurdish army in Republic of Kurdistan in 1946. Barzani went to Soviet Azerbaijan as a refuge, and he return to Southern Kurdistan "under Iraq's power" after that country's 1958 revolution. On paper, Iraq regime signed on the Autonomy Agreement for Kurdish people "Southern Kurdistan" on March 11, 1970. But the autonomy was not implemented and Iraq government did not include Kirkuk to their autonomy region. Mustafa Barzani founds this compromise unacceptable in 1974. So peshmerga started to fight again for freedom. During his life, he led battles against both the Iraqi and Iranian governments.

# Qazi Muhammad

He was born in 1893. He was a Kurdish leader and the president of Republic of Kurdistan. After Republic of Ararat, it is the second modern Kurdish state. Kurdish Republic was smashed by Iranian military, and they sentenced him and two of his associates to death by hanging in Chwarchira Square, in the city of Mahabad, on March 31, 1947. They were left hanging for more than two days. Also in Vasteras, Sweden, his daughter Efat Ghazi was seriously wounded after opening a letter bomb and died after 3 hours On 6 September 1990. Actually the bomb was addressed for her husband Emir Ghazi, the Kurdish activist.

# Leyla Qasim

She is a national symbol among Kurdish. She was born in 1952, Xaneqîn. She joined the Kurdistan Students Union and the Kurdistan Democratic Party in 1970. During her studying at Baghdad University, in 1974 she was accused that she has tried to assassinate Saddam Hussein. She was executed in Baghdad on May 12, 1974.

# Ahmed kaya

He was a Kurdish singer born on October 28, 1957. He died on November 16, 2000 in exile in Paris. He sang in Kurdish and Turkish. He got the prize "Musician of the Year" in 1999, during a ceremony he announced that he want to produce music in his native Kurdish language. That news made Turkish musicians and celebrities throw objects at Kaya. All This led to a prosecution case which made him leave Turkey.

# Sakine Cansiz

She was born in Mamekî around 1958. She was one of the co-founders of the Kurdistan Workers' Party. She was arrested and tortured by Turkish police in 1980. She was shot dead in Paris, France with two other PKK active members Fidan Dogan (also represented the Brussels-based Kurdish National Congress in France) and Leyla Soylemez.

# Mashaal Tammo

He was born in Derbassiyeh in 1958. He was one of the most active Kurdish leaders. He was released in 2010 after spending more than three years in jail. He was assassinated on October 7, 2011 in Qamishli. The day after that more than 50,000 people attended his funeral in Qamishli. Syrian regime fired into the crowds, killing five people.

# Saddam Hussein regime sold Kurdish girls to night clubs.

During Anfal genocide in Kurdistan, there were so many people disappeared by Baathist regime. Still Kurdish people are searching for finding them. After getting documents that Iraq regime sold girls to night clubs to outsiders, people are seeking for finding their relatives. Kurdish merchant announced that he founds 16 girls who had been sold by Iraq regime in Egypt's nightclubs. The prime minister of Kurdistan region, Nechirvan Barzani decided to form committee to find them and know their identity. This case made people and Kurdish government to search everyplace for finding others particularly girls.

# Halabja Massacre

In bloody Friday, on March 16, 1988, as a part of the Al-Anfal campaign, Iraq military attacked Halabja by dropping chemical bombs. This attack killed 5,000 people and injured 7,000 to 10,000, some of them died later because of their wounds. The Iraqi High Criminal Court recognized it as an act of genocide on March 1, 2010. The attack was also condemned as a crime against humanity by the Parliament of Canada.

# Al Anfal campaign

It is known as Kurdish Genocide, led by the Baathist Iraqi President Saddam Hussein and headed by Ali Hassan al-Majid. The process started from 1986, culminating in 1988. For these assaults, the Iraqis mustered up to 200,000 soldiers with air support, with using chemical weapons (mustard gas and the nerve agent GB, or Sarin). They destroyed about 4,000 villages, 1,754 schools, 270 hospitals, 2,450 mosques, 27 churches. Estimating 182,000 Kurds were killed. Sweden, Norway and the U.K. officially recognize the Anfal campaign as genocide.

# Dersim massacre

It was Kurdish uprising against the Turkish government between 1937 and 1938 in Dersim because of The Turkification process. Turkish military attacked people. According to estimates, more than thousands of people died. In 2011, Turkish Prime Minister Recep Tayyip Erdogan gave an apology for the Dersim operation, describing it as "one of the most tragic events of our recent history".

"I composed a Kurdish song and I am looking for a brave producer and a brave TV channel to broadcast it, and I know there are some among you."

Ahmed kaya

"Writing about Kurdish tragedy is like calculating every drop of their Martyrs blood, and their mothers tear."

Besar Kurdistani